M c G R A W - H I L L B O O K C O M P A N Y

NEW YORK • ST. LOUIS • SAN FRANCISCO • MONTREAL TORONTO • LONDON • PARIS • DÜSSELDORF • TOKYO
SIDNEY • KUALA LUMPUR • SÃO PAULO • PANAMA • MEXICO JOHANNESBURG • NEW DELHI • AUCKLAND • SINGAPORE

LANDSCAPE

PAUL CAPONIGRO

Library of Congress Catalogue Card Number 75-24797
ISBN 07 009 780 1

*Printed in The United States of America
by the Rapoport Printing Corporation.
Designed by E.M.*

*Photographs number 10, 12, 16, 35, 50, 54, 60, 61, 62,
were made with Polaroid material.*

2345678910 RPC 798765

PHOTOGRAPHS

LANDSCAPE

From the beginning, nature was for me a world of exploration and discovery, of experience and wonder, a world of both constant rhythm and ceaseless change. I saw isolated objects—stones, trees, blades of grass, hills—as individual worlds relating to a larger whole, the landscape. As I looked further into nature, I began to catch glimpses of mysterious depths. Boundaries of separate objects lifted and opened, the land seemed charged with potent force and magic, alive and moving.

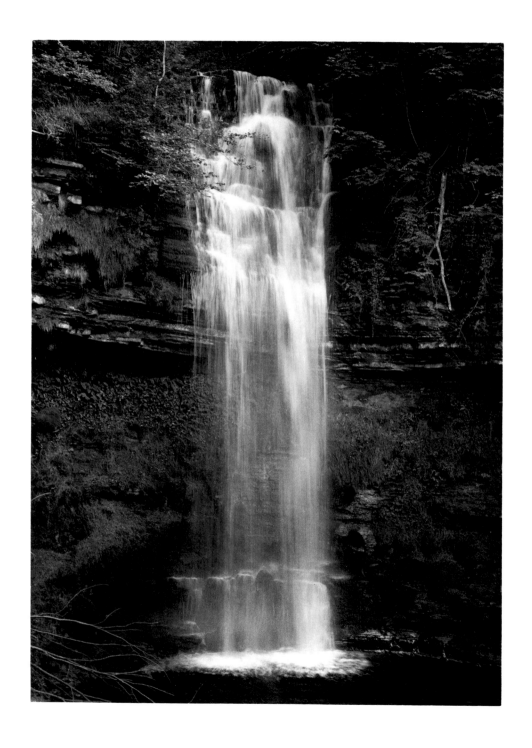

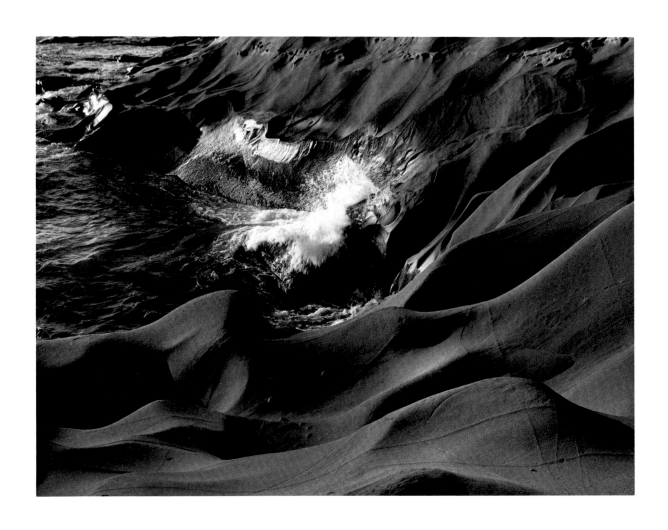

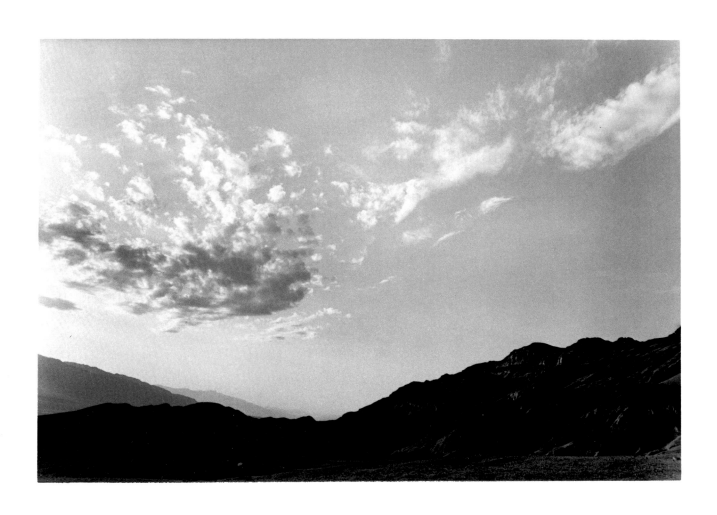

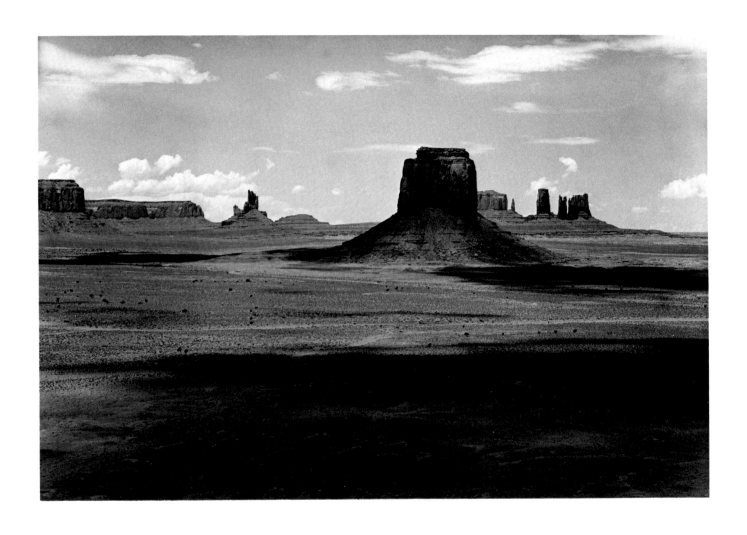

4.

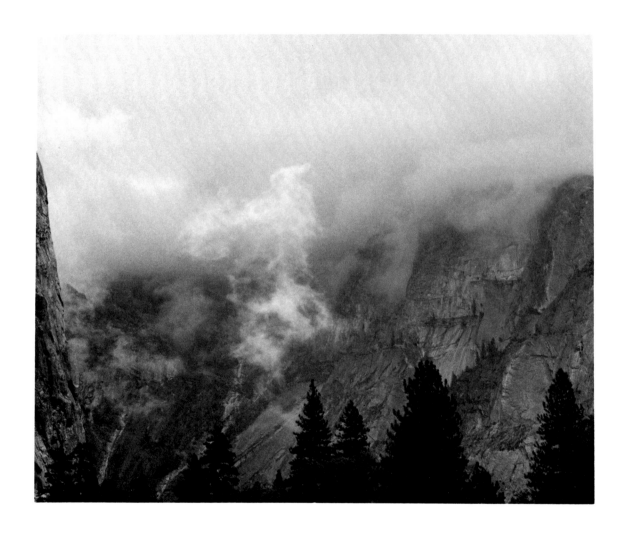

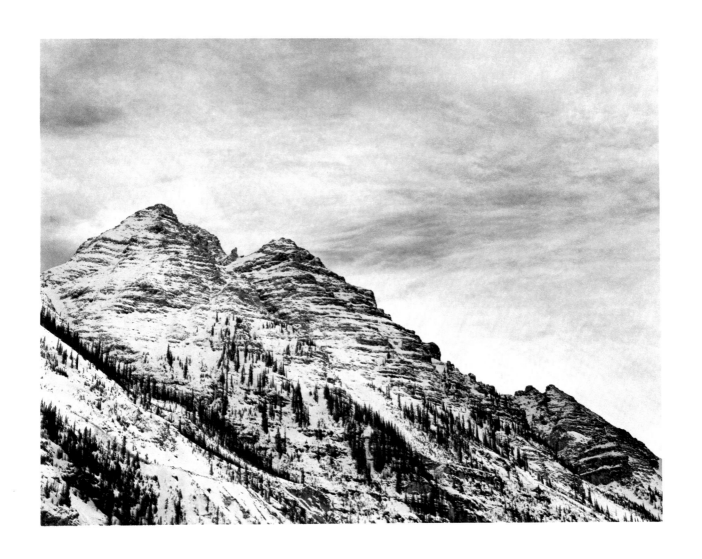

6.

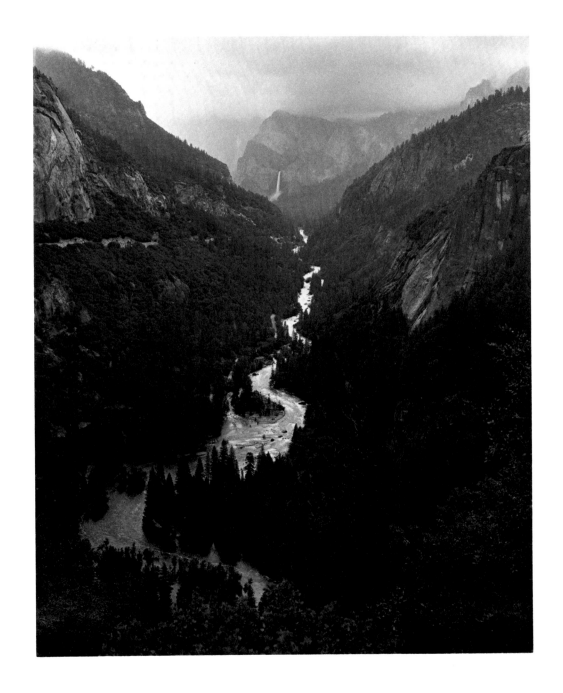

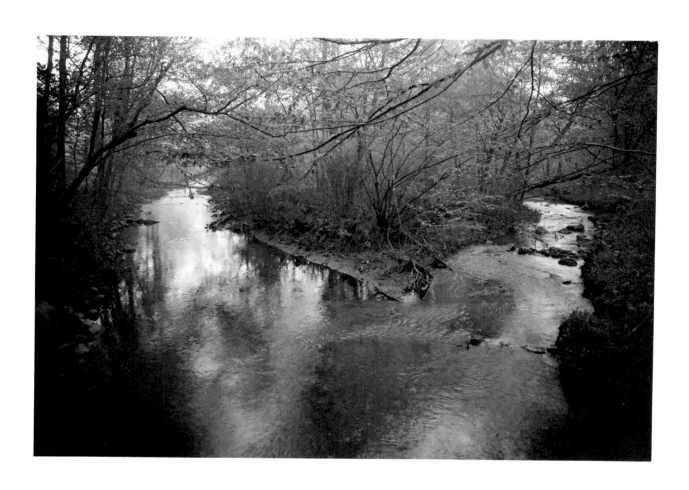

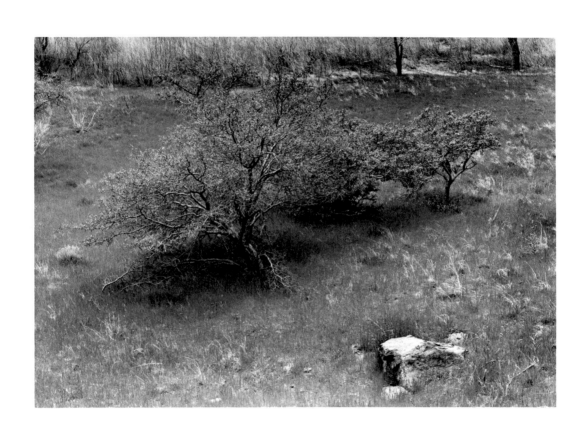

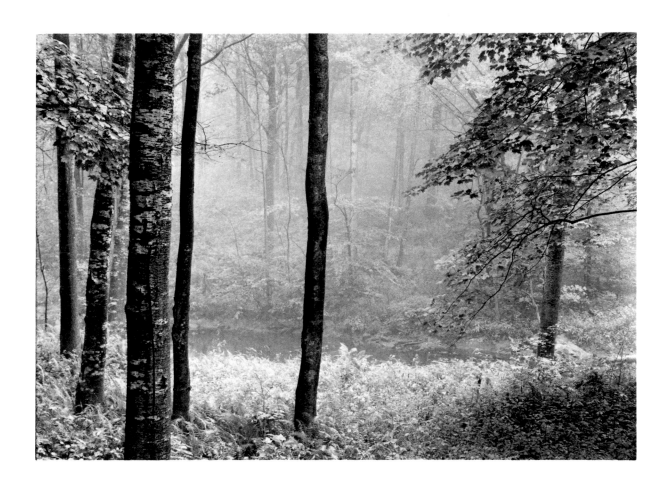

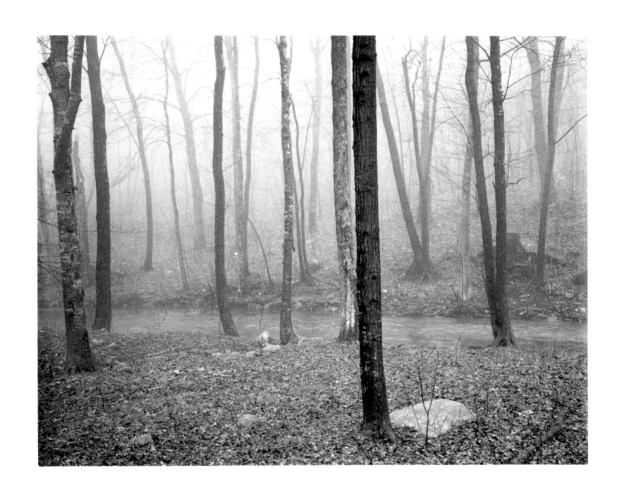

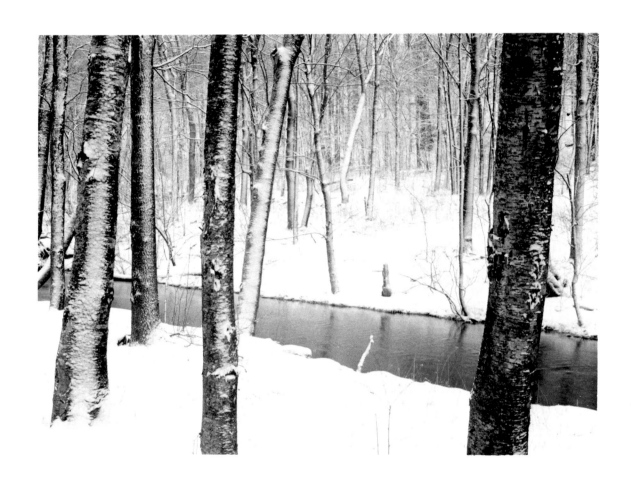

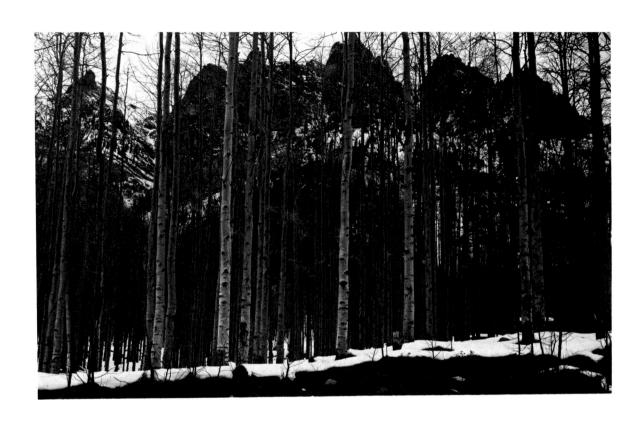

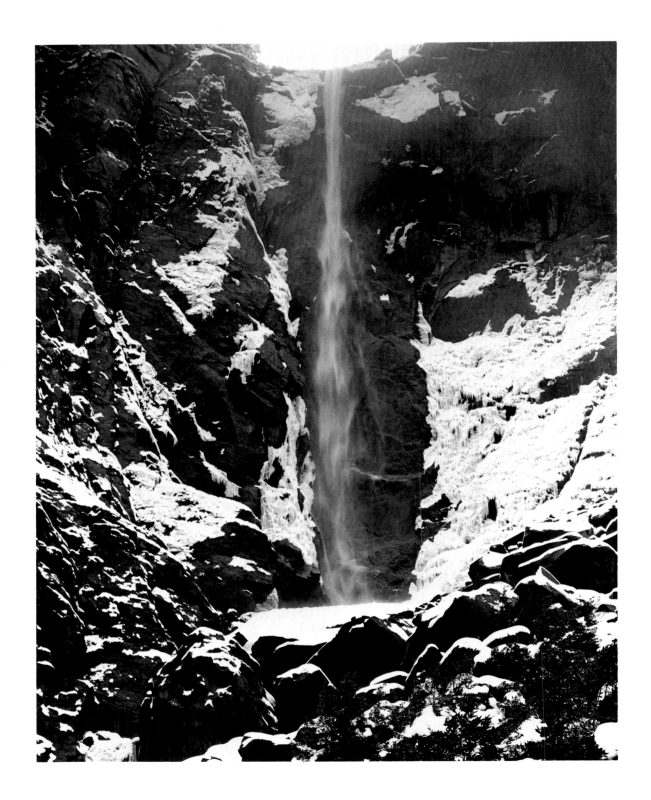

14.

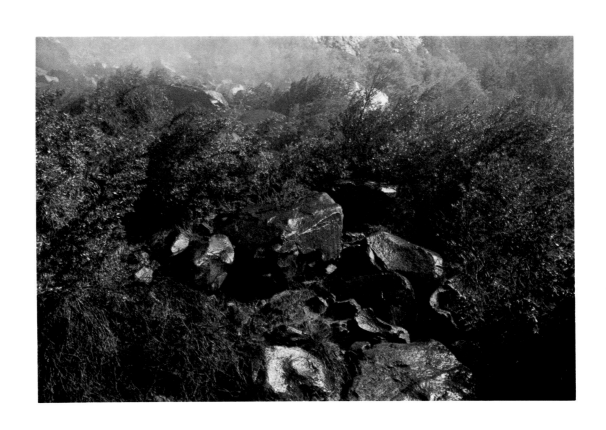

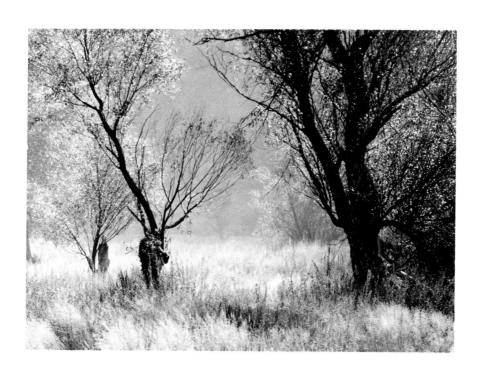

16.

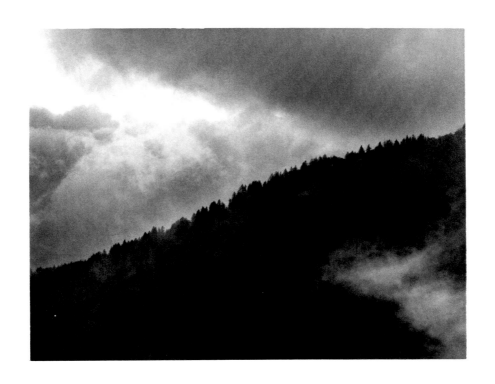

I began to record nature with a camera, and as I slowly gained ability with photography I came to see its great potential for personal exploration and discovery. Photography, itself, became for me a new landscape. The etching power of light, the response of chemical emulsions, the transformation of objects through the lens, the subtle tones of the black and white print, all became for me a landscape of discovery and delight.

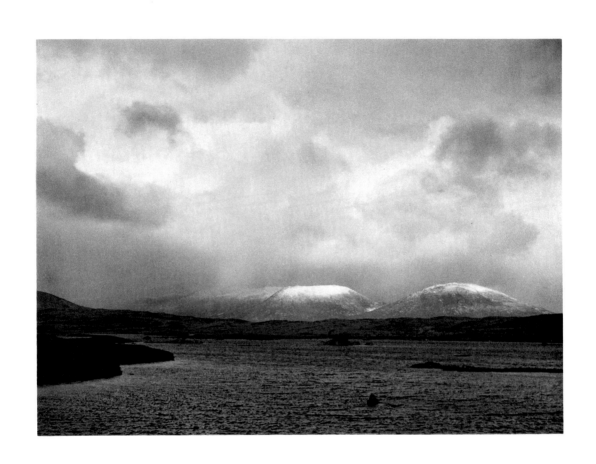

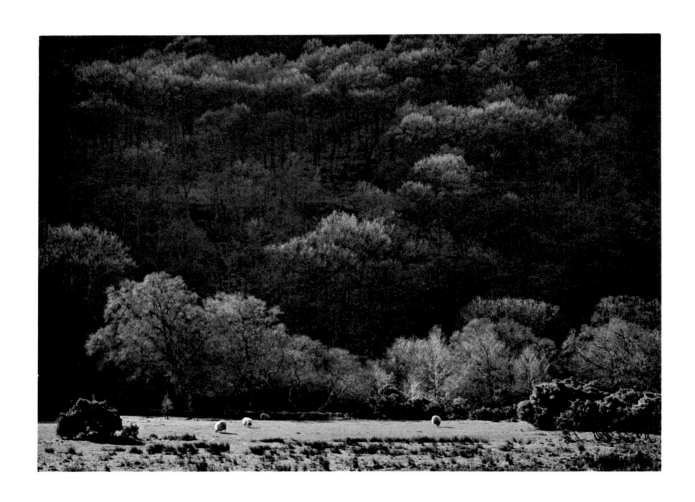

19.

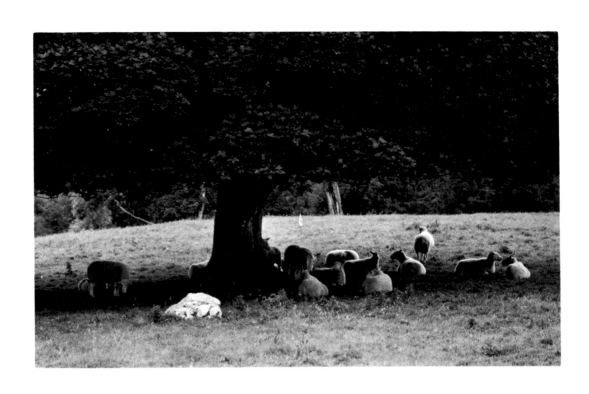

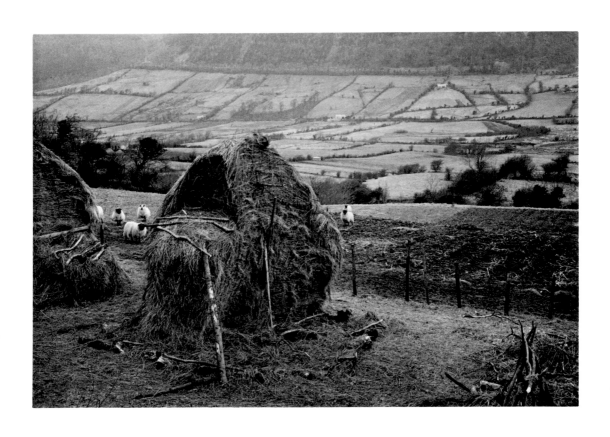

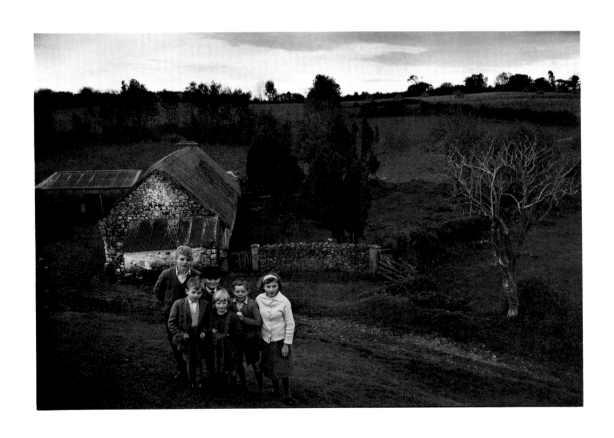

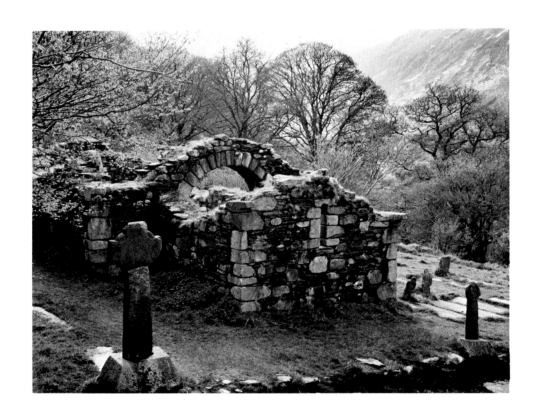

23.

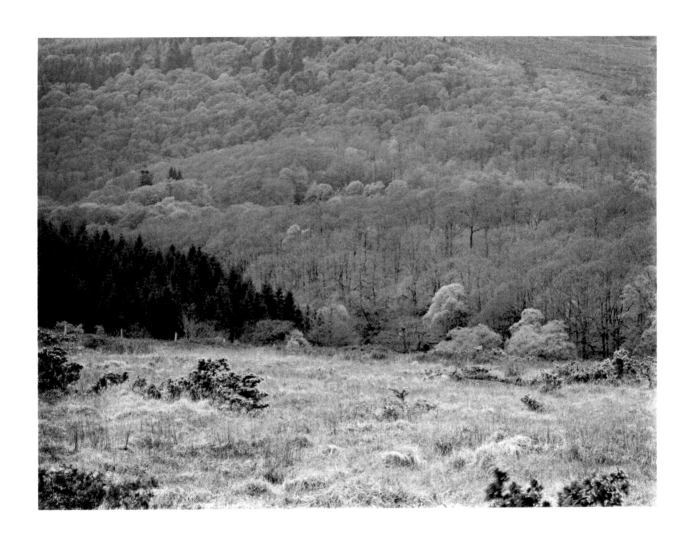

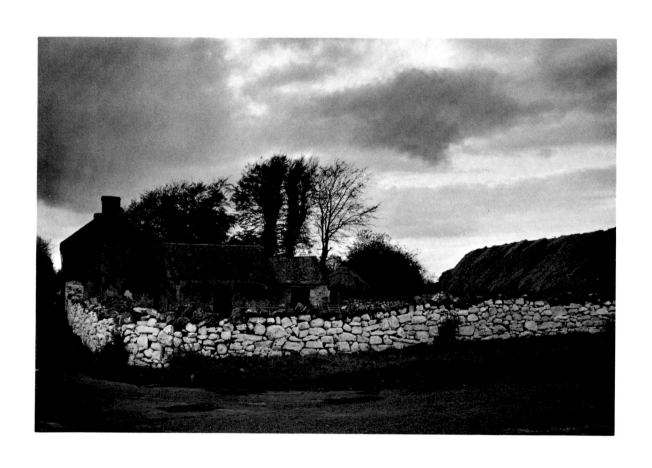

25.

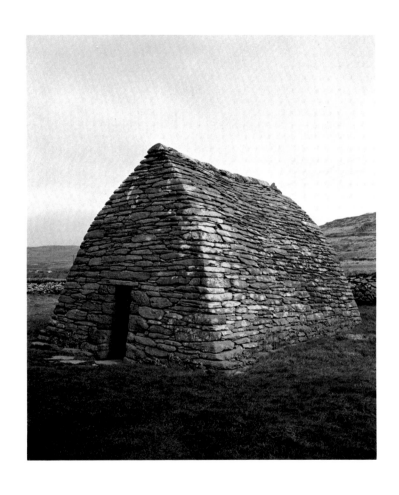

26.

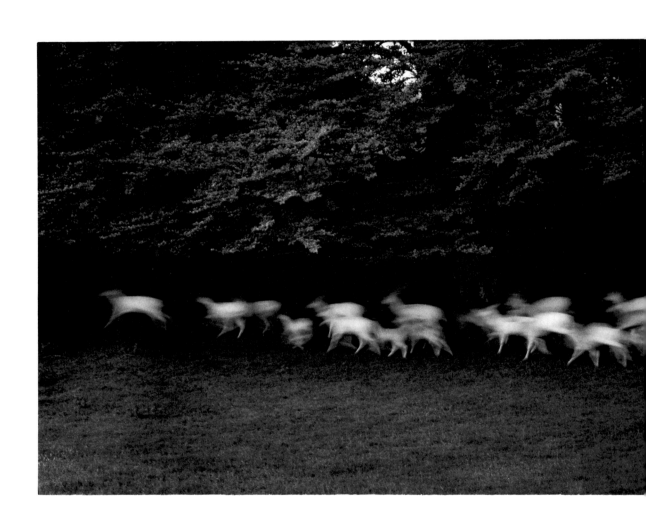

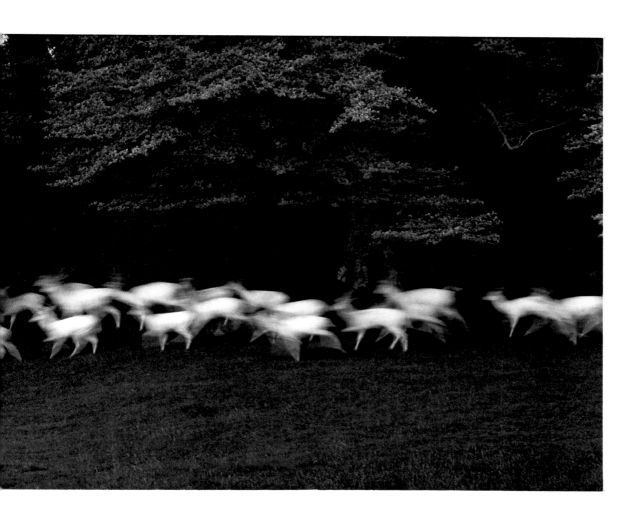

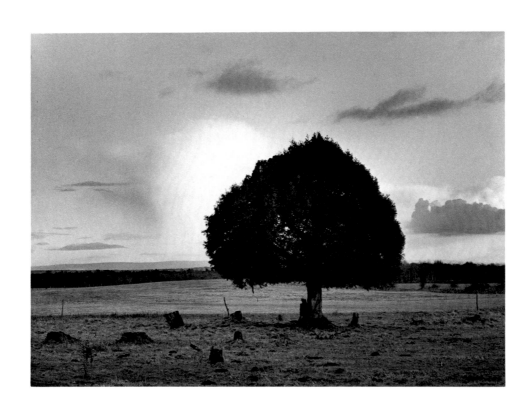

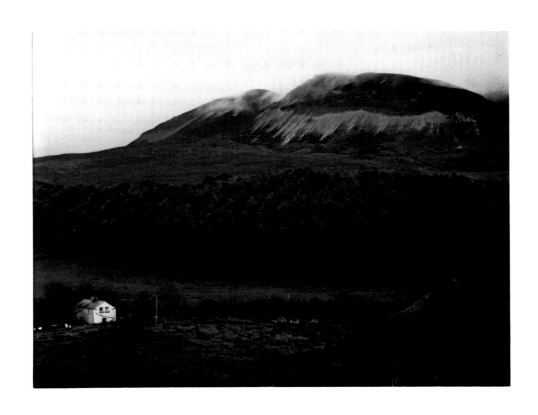

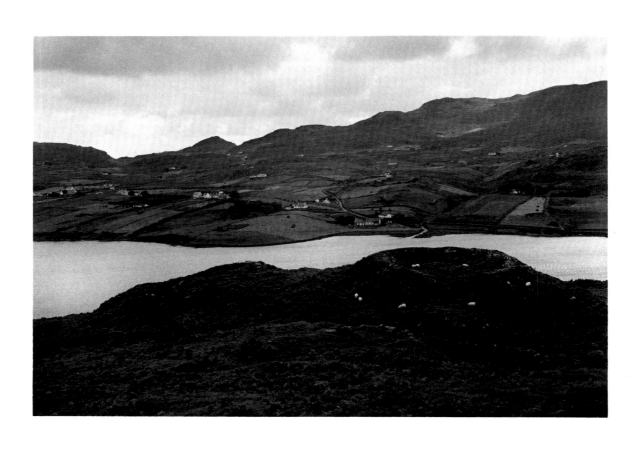

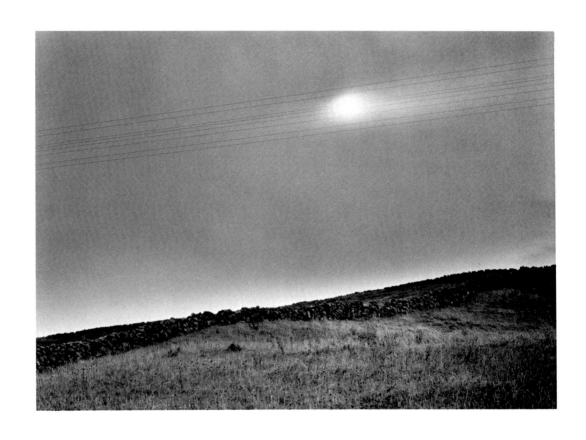

It seemed to me that I was exploring two separate worlds, and that somehow I must unite the two. Through the use of the camera, I must try to express and make visible the forces moving in and through nature. But the limitations imposed by the technical aspects of the medium were still restrictive, cutting me off from a sense of rapport with the constant flow of nature. Through the camera I brought back only hints, intimations of the possibilities for capturing in silver the elusive image of nature's subtle realms. My concern was to maintain, within the inevitable limitations of the medium, a freedom which alone could permit contact with the greater dimension—the landscape behind the landscape.

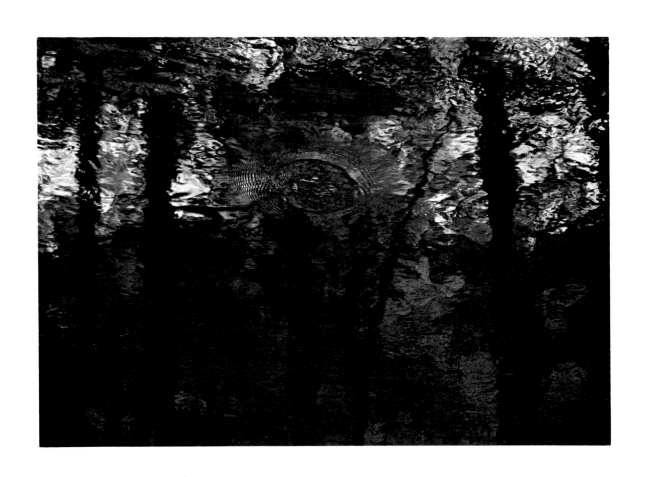

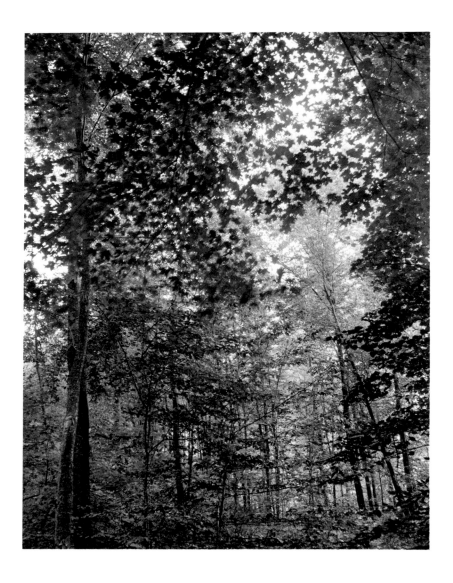

33.

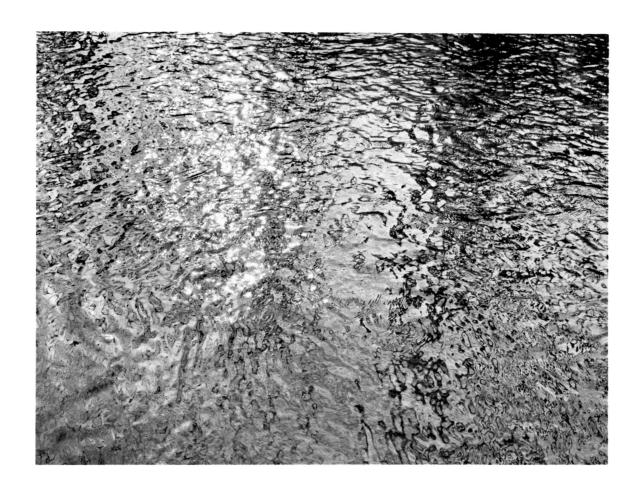

34.

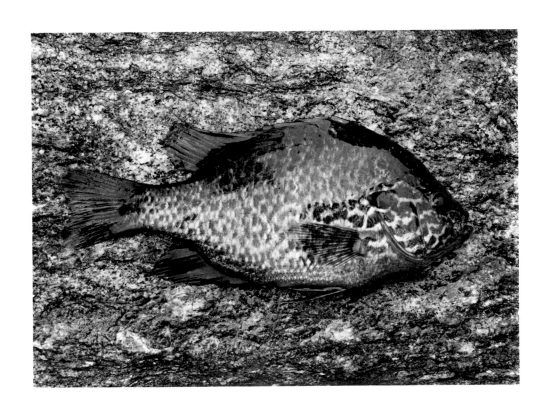

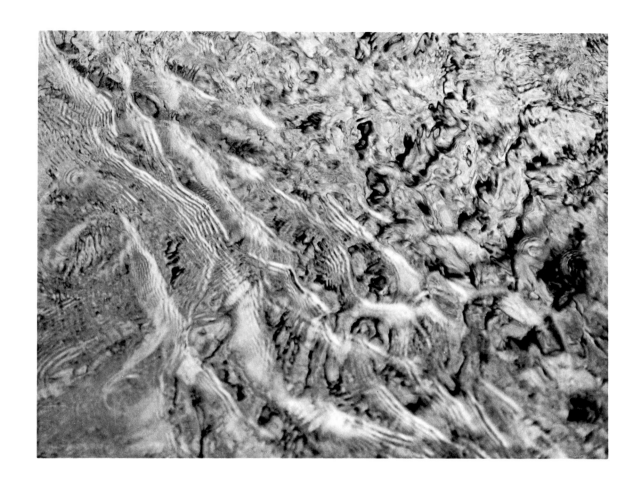

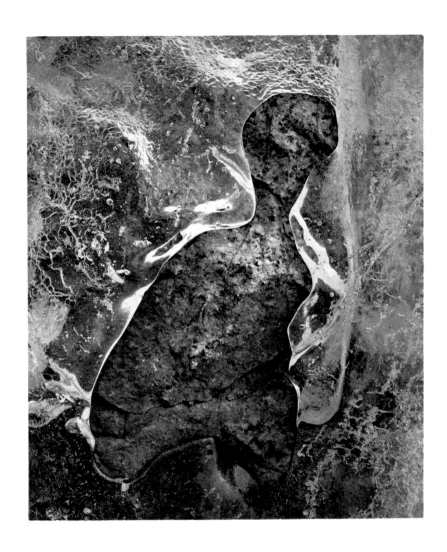

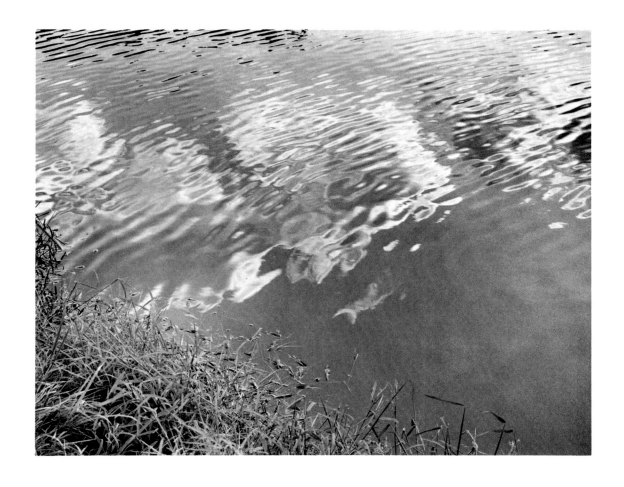

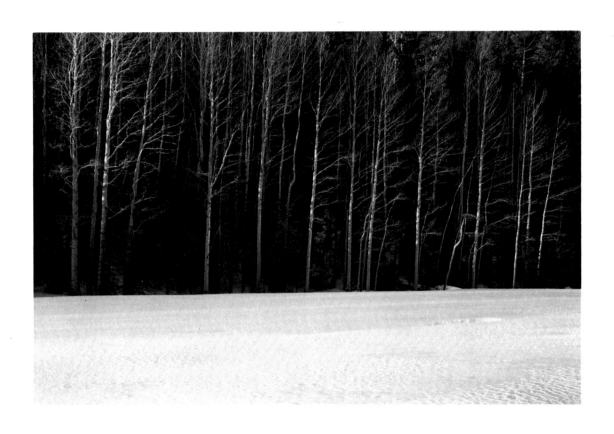

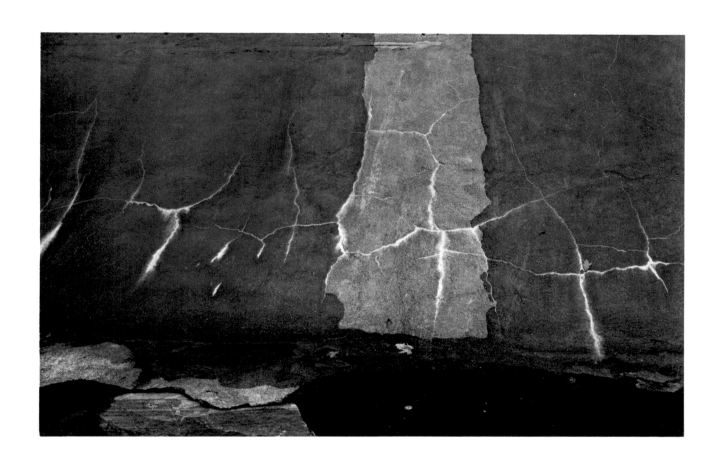

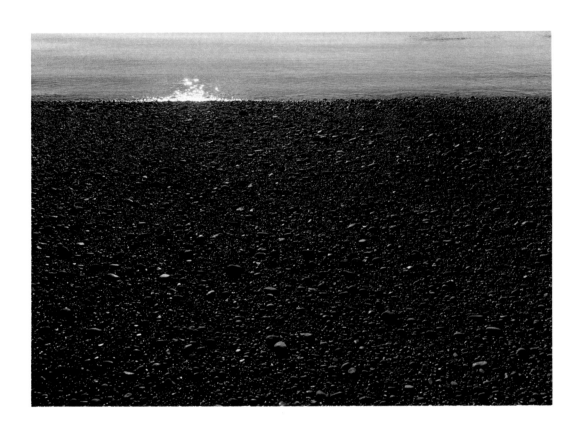

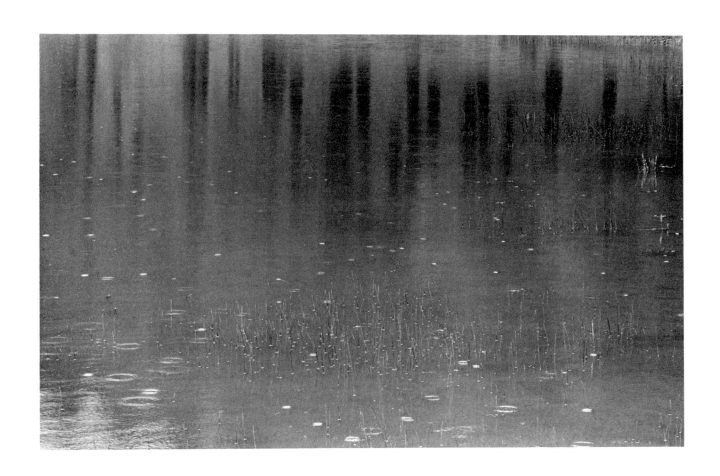

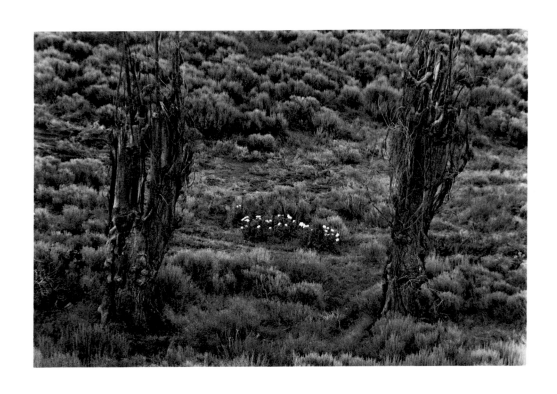

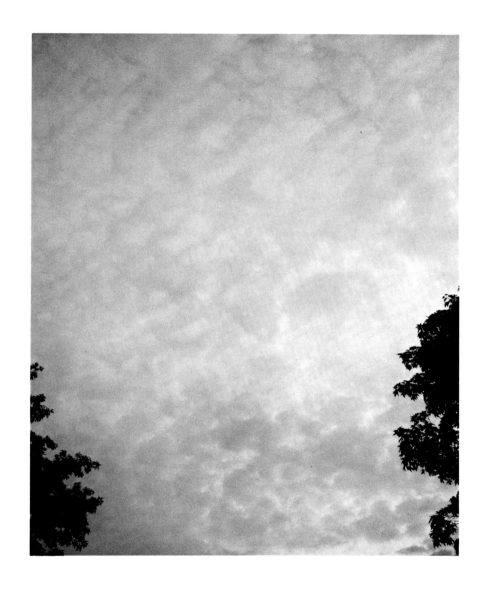

Gradually, some very few photographs began to make visible the overtones of that dimension I sought. Dreamlike, these isolated images maintain a landscape of their own, produced through the agency of a place apart from myself. Mysteriously, and most often when I was not conscious of control, that magical and subtle force crept somehow into the image, offering back what I sensed as well as what I saw.

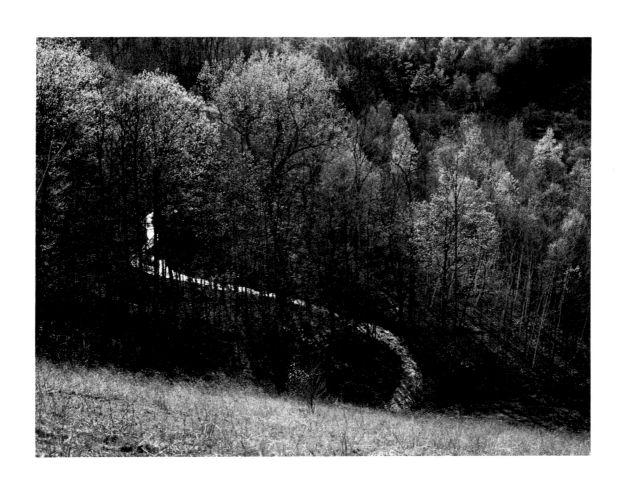

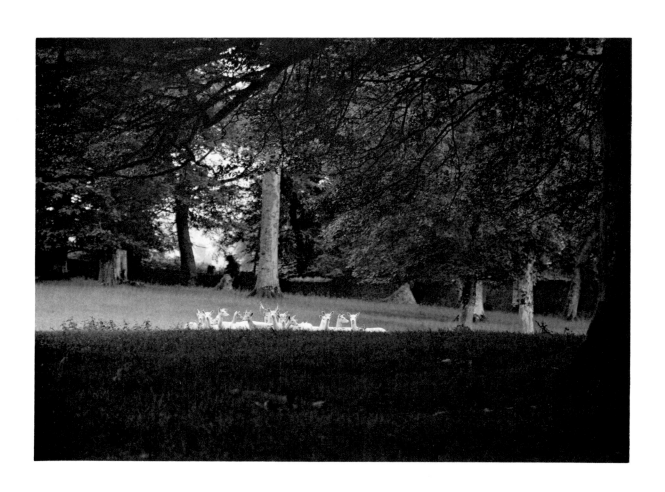

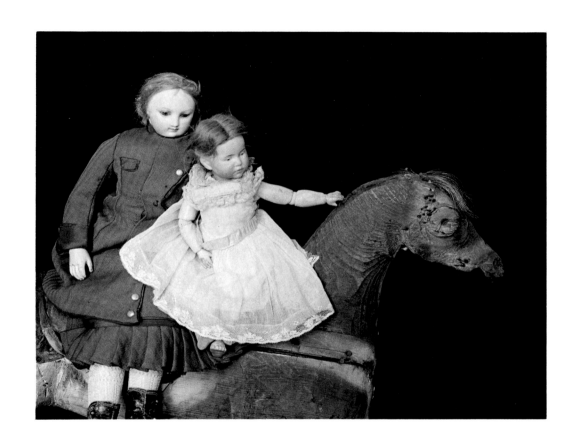

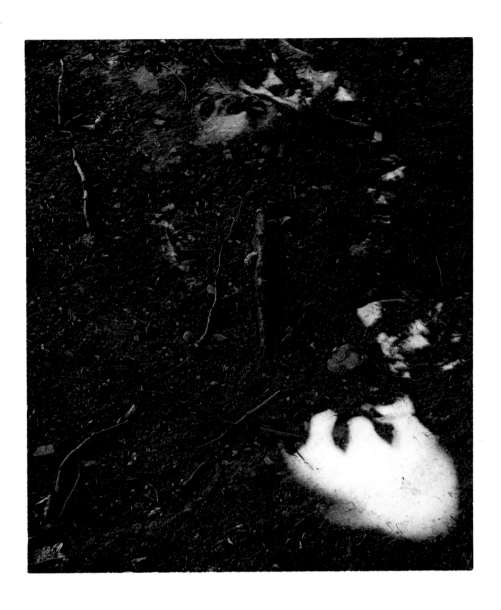

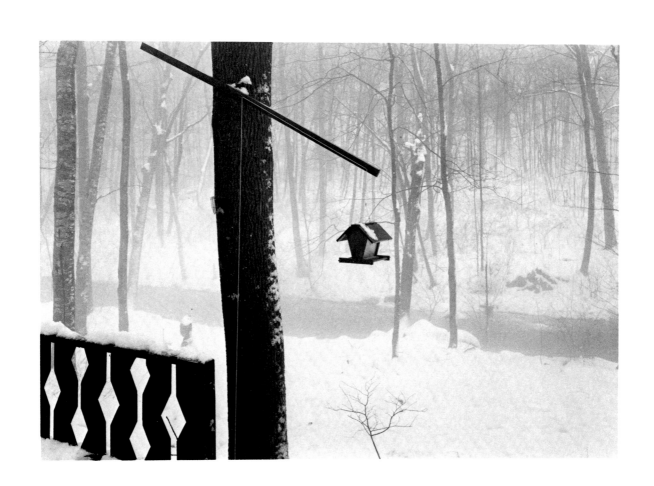

49.

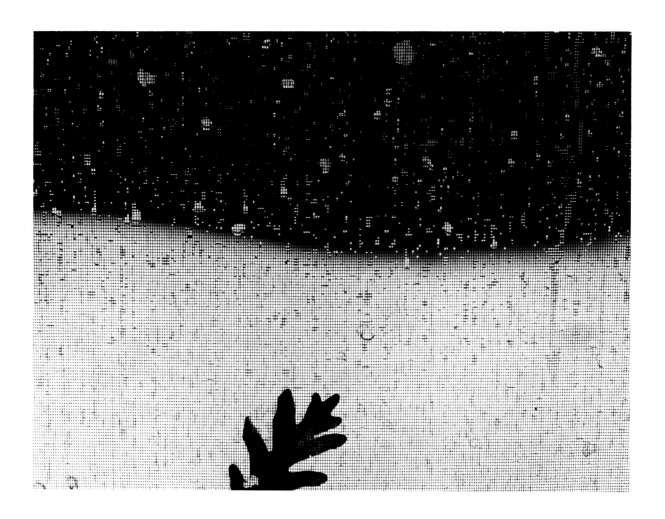

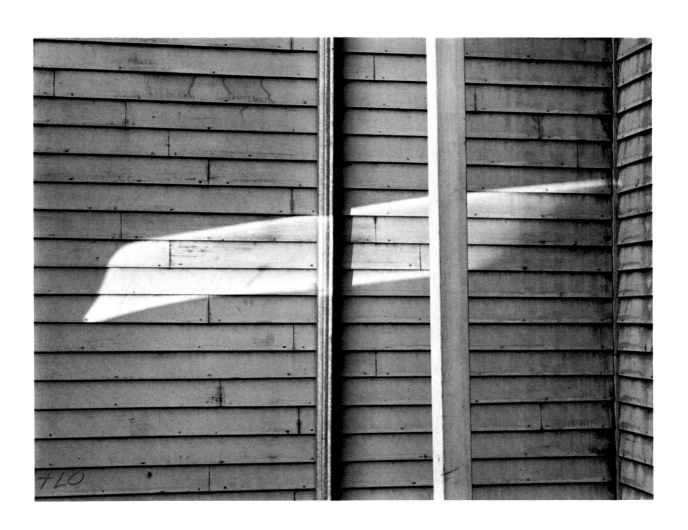

51.

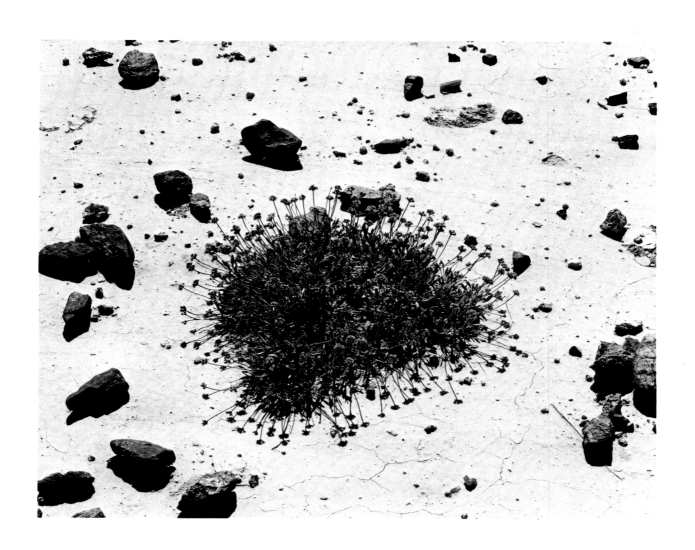

52.

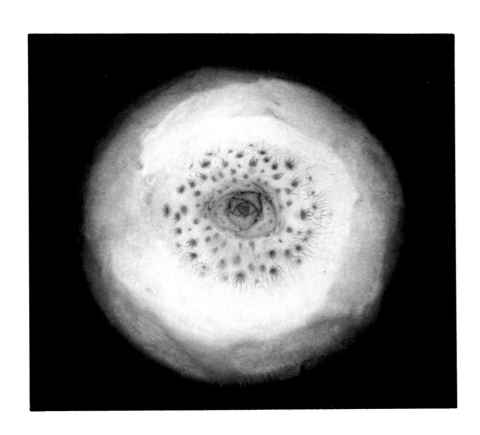

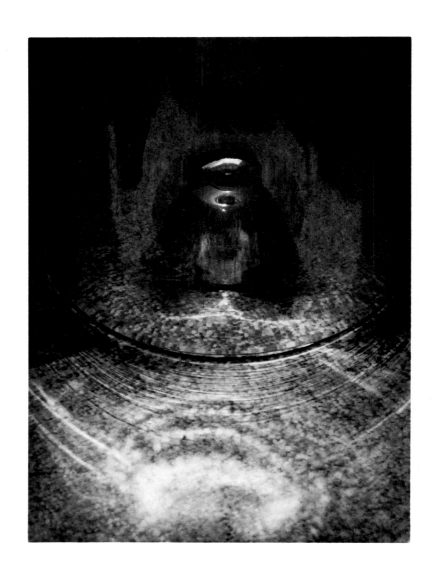

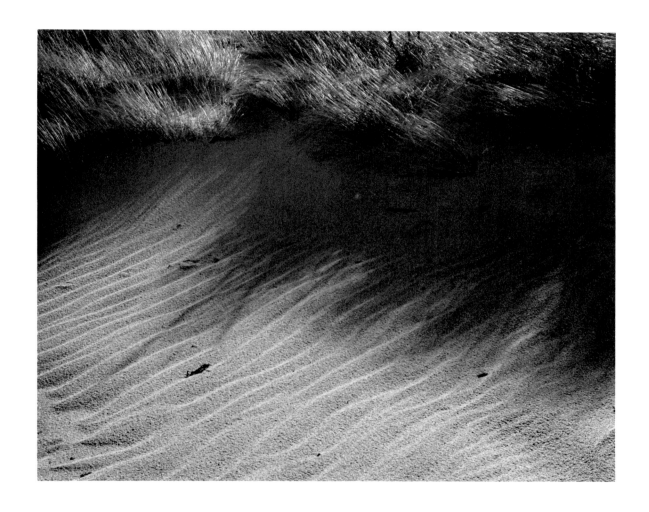

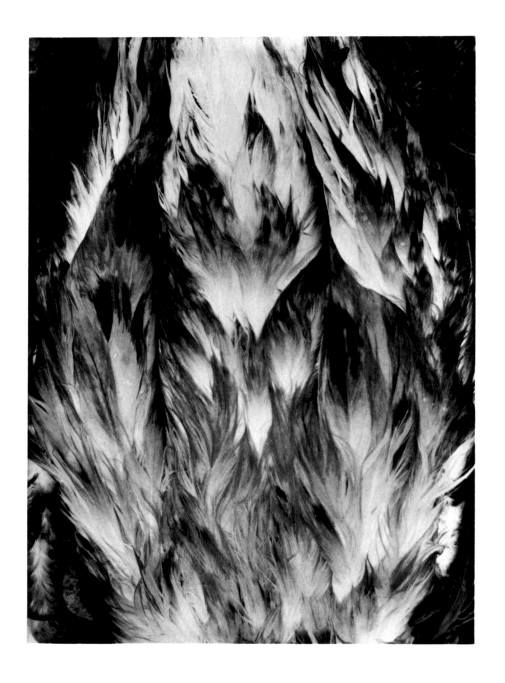

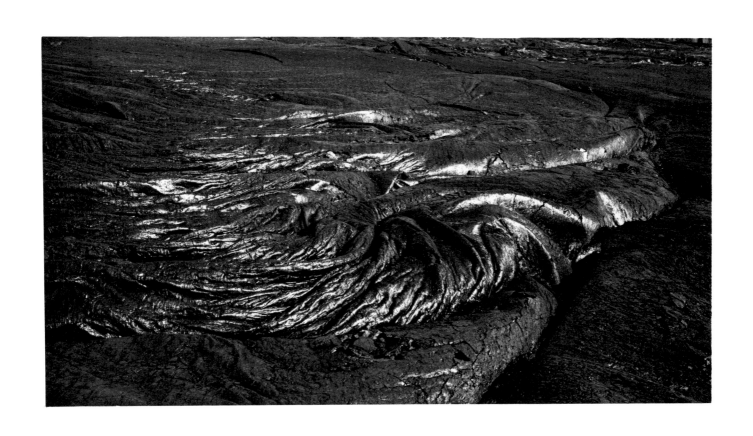

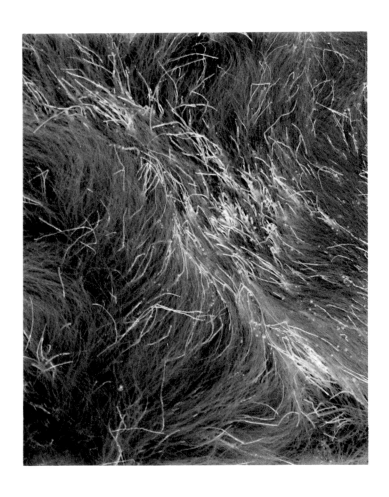

58.

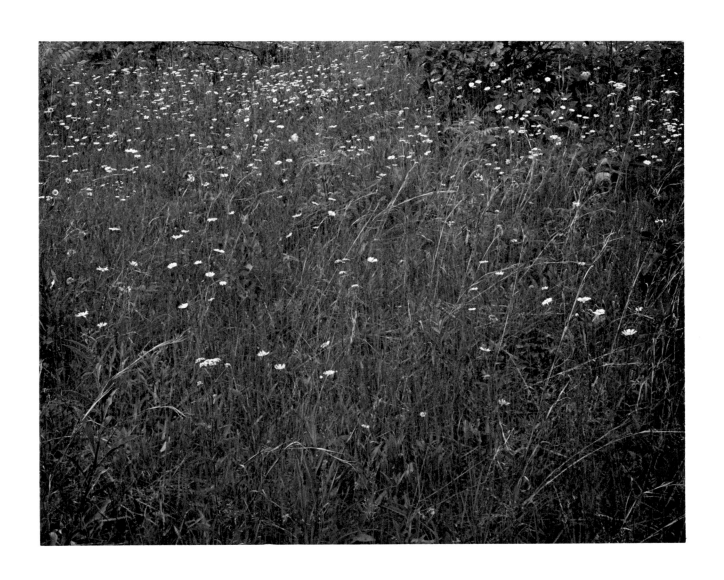

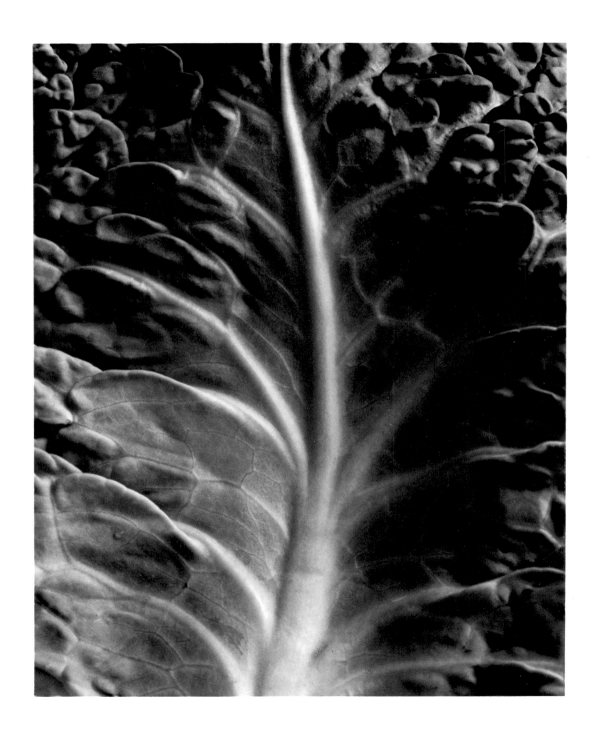

60.

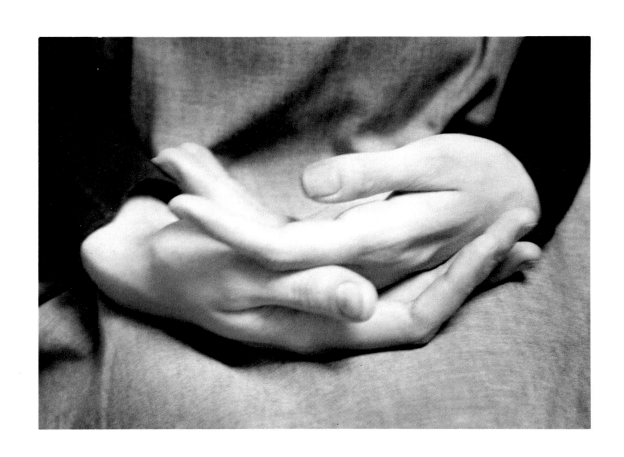

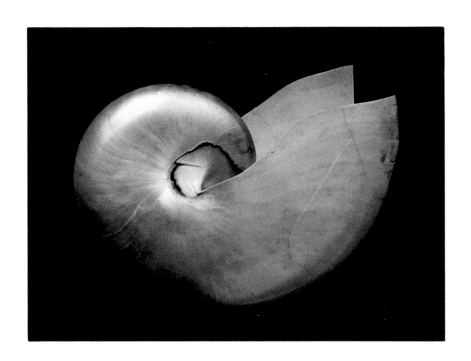

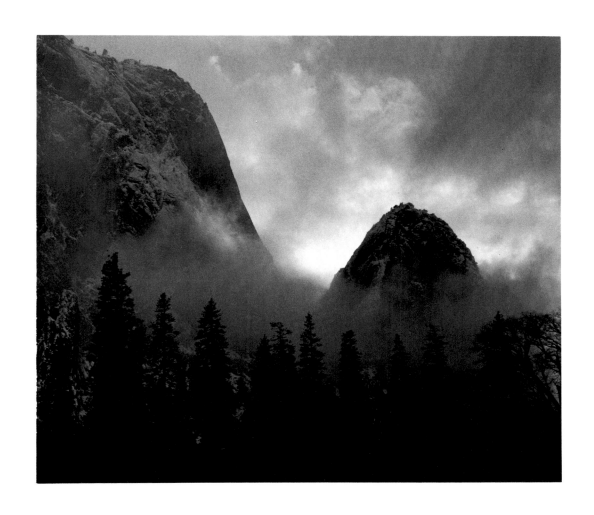

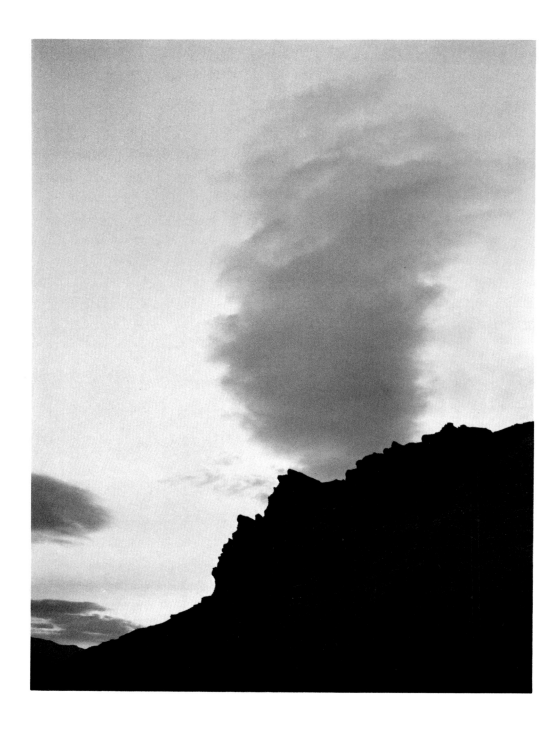

64.

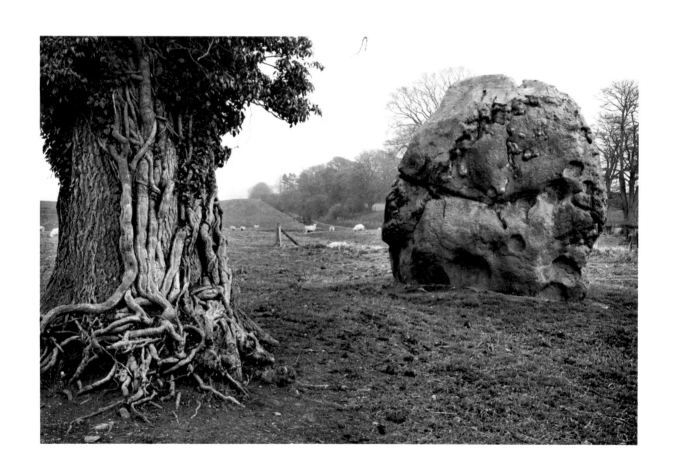

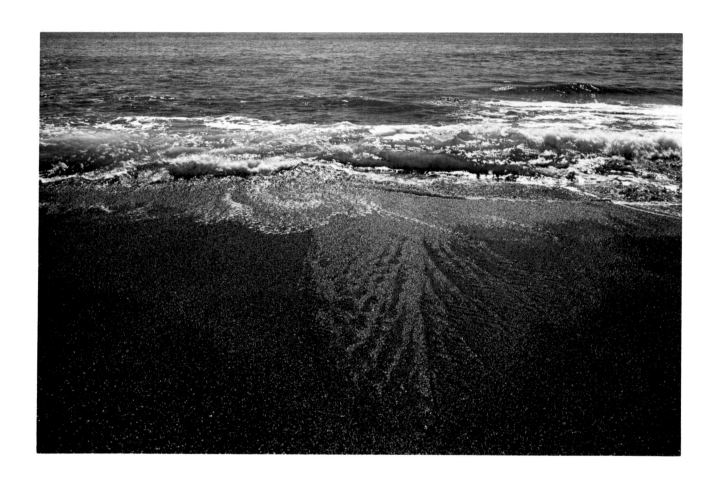

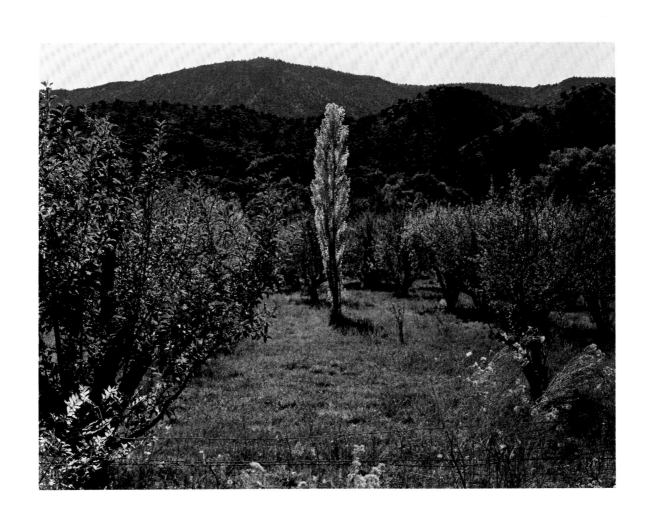

67.

All that I have achieved are these dreams locked in silver. Through this work it was possible, if only for brief moments, to sense the thread which holds all things together. The world, the unity of force and movement, could be seen in nature—in a face, a stone, or a patch of sunlight. The subtle suggestions generated by configurations of cloud and stone, of shape and tone, made of the photograph a meeting place, from which to continue on a even more adventurous journey through a landscape of reflection, of introspection.

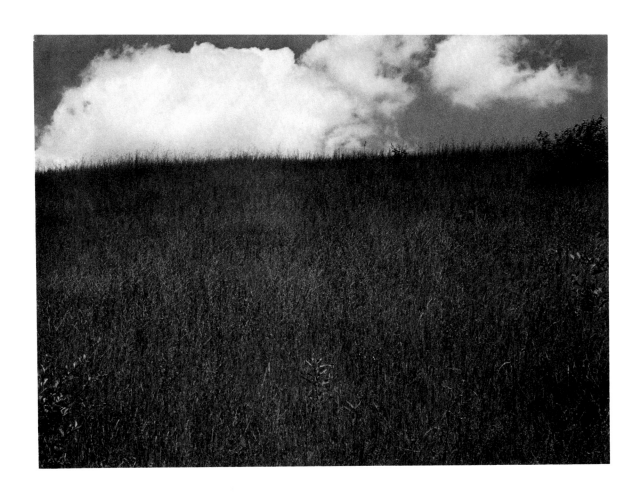

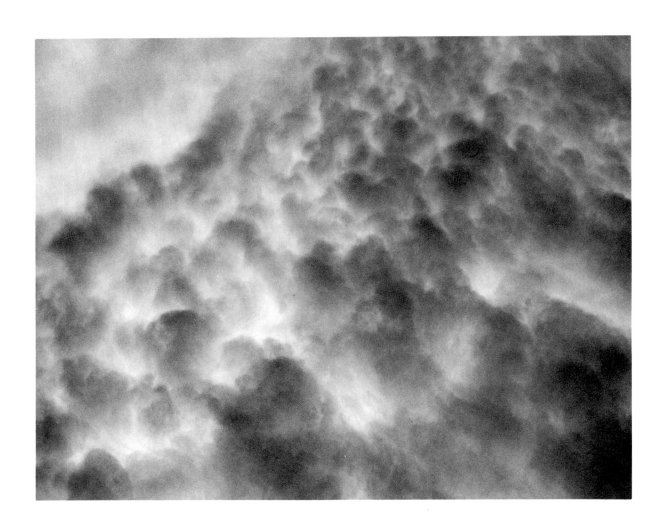

69.

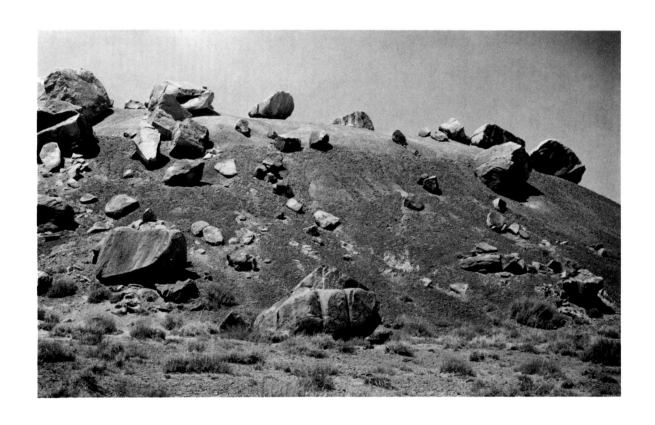

70.

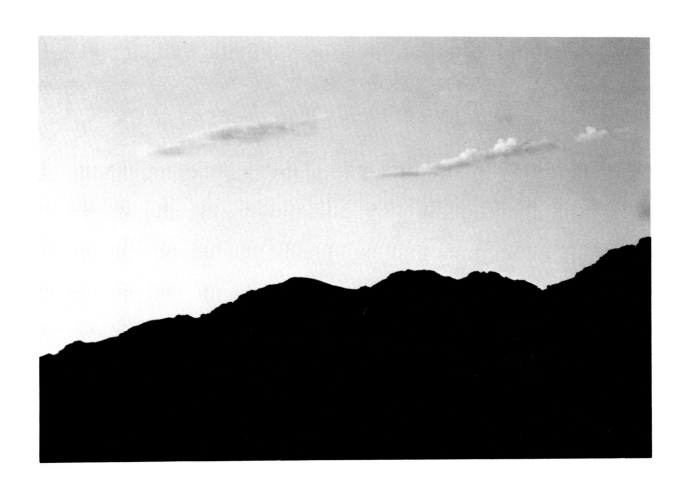

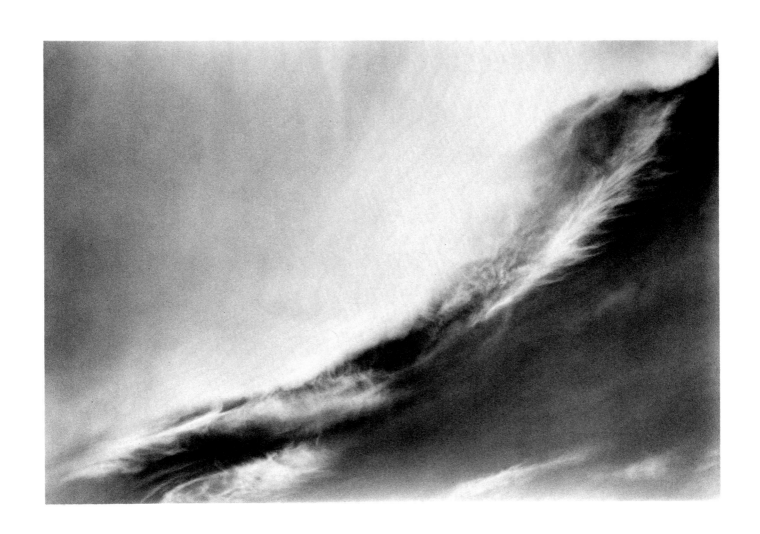

72.

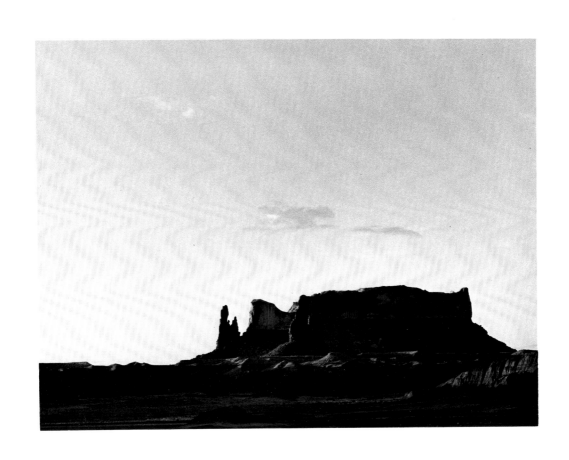

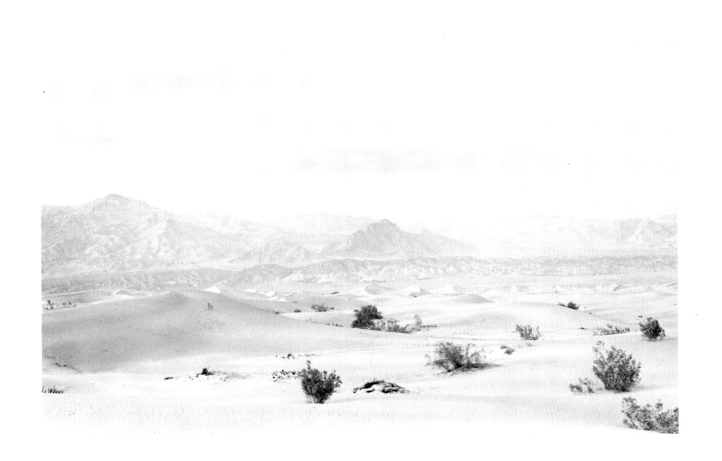